Praise for *Aphorisn*

T0031581

"I'm always up for an aphorism! Anc

—Laurie Anderson, artist

"Darby Bannard's *Aphorisms for Artists* is exactly what one might expect—super-intelligent, pithy, vivid, wise, and taking no prisoners. Anyone lucky enough to have known Darby will recognize his inimitable voice."

—**Michael Fried**, author of *Art and Objecthood*

"Darby Bannard was a fiercely intelligent, deeply knowledgeable, inventive abstract painter. He was also an influential teacher, and a splendid critic and writer about art, with a wicked wit, capable of summing up and often skewering whole movements with a pointed phrase. While he was intolerant of one-liner art, his condensed critical observations are illuminating and memorable. Reading his aphorisms brings this smart, articulate, gifted artist back to vivid life."

—**Karen Wilkin**, critic and curator

"From the outrageous, to the benign, to the wonderfully insightful, Walter Darby Bannard's aphorisms are provocations for 100 never-ending—and absolutely essential—arguments about art. Quote one of 'em at an artists' bar, and you're there for the night—buying a few rounds when you lose."

—**Peter Plagens**, artist and critic

"In the writings of Walter Darby Bannard I found a more concise understanding of the major focus of Clement Greenberg's work: Visual art is about looking, as food is to tasting and smelling. Art can certainly share stories, just as we have stories of the meaningfulness of certain meals. Yet in the end, it is taste that matters. That taste develops the more we experience. *Aphorisms for Artists* compiles Bannard's short, cogent messages for artists and art enthusiasts of all ilk, to help us grasp something that is often too ephemeral for words. I find myself coming back to them time and time again, especially 'Art is as persistent as it is fragile.' I am confident that *Aphorisms for Artists* will inspire, and with each read we will understand more about the value of art, 'telling us what's good about us.'"

—**Mark Golden, Golden Artist Colors**

"Darby was a faithful artist and a faithful friend, and lovingly used to call me a coot."

—**Larry Poons, artist**

"Ken Noland introduced me to Darby. I thought he was a terrific painter and should be in "The De Luxe Show." He used paint differently than anybody else I knew."

—**Peter Bradley, artist**

APHORISMS
FOR ARTISTS

APHORISMS
FOR ARTISTS

100 Ways Toward
Better Art

WALTER DARBY BANNARD

ALLWORTH PRESS
NEW YORK

Allworth Press books may be purchased in bulk at special
discounts for sales promotion, corporate gifts, fund-raising, or
educational purposes. Special editions can also be created to
specifications. For details, contact the Special Sales Department,
Allworth Press, 307 West 36th Street, 11th Floor, New York, NY
10018 or info@skyhorsepublishing.com.

28 27 26 25 24 5 4 3 2 1

Published by Allworth Press, an imprint of Skyhorse Publishing,
Inc., 307 West 36th Street, 11th Floor, New York, NY 10018.
Allworth Press® is a registered trademark of Skyhorse Publishing,
Inc.®, a Delaware corporation.

www.allworth.com

Cover design by Mary Ann Smith
Cover painting by Walter Darby Bannard, #4 (9.9.59), 1959,
spray paint on paper, 16.75 x 14 inches, © Estate of Walter Darby
Bannard, courtesy of Berry Campbell, New York

Library of Congress Cataloging-in-Publication Data is available
on file.

Print ISBN: 978-1-62153-839-4
eBook ISBN: 978-1-62153-840-0

Printed in the United States of America

Foreword

by Franklin Einspruch

You are holding in your hands the distilled
wisdom of a quarter-century of teaching that
crowned a lifetime of creation. Its author, Walter
Darby Bannard, was one of the great talents of
American painting. Making art in a serious way
is often difficult, but the difficulties are rarely
altogether unprecedented. Darby probably
had to solve them for himself at some point.
His solutions collected here can help you to
do likewise. They are simple. That is not to say
that they are easy, but that they require courage,
humility, and will rather than mere intelligence.
I attest that they work.

In 1923, Margery Ryerson published the
collected wisdom of her teacher at the Art
Students League, the painter Robert Henri, as
The Art Spirit. (It remains in print to this day
and continues to inspire.) This book came about
in a similar way. I studied under Darby in the

1990s at the University of Miami, and I edited an archive of his writings. Darby spent a long teaching career watching students suffer, then succeed, then go back to suffering in the process of learning to make art. Most of the time they (myself included) were struggling through a problem that he had already encountered.

Some of these were technical problems, which Darby could dispel in five minutes. Others were larger problems concerning what art is for, and what it does—the kind of problems that you are doomed to solve on your own. But here, too, he had many useful insights. Darby loved a good chat, but as befits an astute thinker, much of his best advice was epigrammatic. As a student, it was sometimes infuriating to watch Darby take your artistic problem, made overwrought by your thinking about it in the wrong way, and slice through it like Alexander's sword through the Gordian Knot. Part of you, the self-important part, wanted to tie the metaphorical bits of cord back together. (Some students succeeded in doing so.) But if you had any sense, you restrained it, and instead made art according to your nature and the nature of your materials. Thus his teaching continued for more than two decades, shaping the creative lives of countless students.

Darby did us a great service by condensing those years of instruction into this book of aphorisms, which is presented for your edification and assistance. They are not meant to be rigorous as philosophy or sound as theory. In the intellectual context of contemporary art, they are all disputable. (What isn't?) But again and again they advise you to set aside that context and look at art, yours and others', as it is.

Some of the remarks are specific to painting, but only for the sake of the prose, and because it was the author's medium. Substitute another discipline for "painting" and they will still pertain. If you aspire to establish a serious, heartfelt studio practice, regardless of your medium or style, you will recognize them as true. If you want only to look at art in a more sensitive way, they apply to that as well.

"What we need is more sense of the wonder of life, and less of the business of making a picture," said Robert Henri. But to take care of the business of making a picture—to take care of it in every respect—connects you to the wonder of life.

Listen as Darby tells you how.

Introduction

by Walter Darby Bannard

Decades ago, when I started teaching studio art
regularly, it seemed like a good idea to publish
essays outlining the salient characteristics of
certain examples of good and bad art, in the
hope that people would go look at the art
and agree with me, or not, as they chose, and
intelligent dialogue would ensue.

It didn't turn out that way. A few folks would
read an article and compliment me on my
writing, but attempts to engage in further
discussion usually revealed that the article was
read carelessly and barely understood. Those
who disagreed with my points talked to others
who also disagreed, but not to me. The articles
rather quickly slipped into obscurity.

It also seemed appropriate to surround hard-
core studio instruction with an insulating layer
of persuasive reasoning. I learned, however, that

good students will eagerly try anything anyway, and lesser ones will, one way or another, resist everything no matter what you tell them. I now simply tell students what my eye tells me: "That is working. That isn't. Try this and let me know how it turns out." Why waste time?

"There are no rules in art," so they say. Well, yes and no. Long experience with art, art writing, and art instruction assures me that, indeed, there is no way to specify what good art is or how to create it, but that certain principles, like gold in a pan, eventually wash clear enough to express in a few words.

This is what I have done here. I hope this book is helpful and enjoyable. If not, please give it to someone else.

APHORISMS
FOR ARTISTS

Good art is good art. Period.

Most people like potatoes, but if I don't like potatoes, it is "just a matter of taste." This is how we react to people's likes and dislikes.

However, as Kant said, when a work of art is good it is good for everyone, good for all people, whether they like it or not, or even care.

Way down deep we are pretty much all the same. Taste, if we have it, is what takes us down to where art lives.

Art is not "about." Art is.

Things are defined by use. A work of art is a
work of art because we call it a work of art, but
it is not actually a work of art until we ask it to
function as art so we can experience it as art.

If we ask it to be something else—illustration,
decoration, political message, cover for a hole
in the wall, or whatever—it becomes, for the
moment, something else.

I don't want art that needs fixing.

I want art that sends me back
to the studio to fix my own.

There's a certain sour pleasure looking at work and seeing its faults and knowing how it could be better. Years of teaching has made this automatic for me. Unfortunately, this happens too much of the time.

There is nothing like the provocative thrill of finding something that looks right back at me and asks, "Is your work this good?"

Good art does not break with the past.

It breaks with the present by emulating the best of the past. Good art looks new because the artist has recombined something old to make something better.

Modernism seems to tell us that art has to be new to be any good, but artists who strain to make art that looks new usually make art that looks like other artists who are trying to make art that looks new. This is why most of the art of any time looks dated.

Art is too popular.

There are too many artists, too many dealers,
and too much art. If plumbing was as popular
as art, we would have amateur plumbers
running around in stained clothing, brandishing
plungers, climbing in and out of sewers, and
writing gibberish about pipe systems.

And none of our toilets would work.

Good art is the product of
an integrated personality.

Artists are known for their eccentricity,
but somewhere in their heads something is
working right.

I think that the notoriety of artists is caused by
their habit of going their own way and doing
what they want to do, no matter what anyone
thinks.

This sets them apart from the crowd, which
consists of people acting very strangely but in
socially acceptable ways.

See first. Name later.

If we see an object as a "bowl," it may inhibit
our seeing it as "craft," just as seeing it as "craft"
might inhibit seeing it as "art." And vice-versa.

Keep categories out of it. The only question is
this: Does looking at it give me pleasure?

New art is not always good art,
but good art is always new art.

An art writer once wrote that "stale artifacts of the past" are "irrelevant" because they are not "active components of the present moment."

But "stale artifacts of the past" are always "active components of the present moment" when they are experienced in the present moment. To an art historian, a Giotto is a fourteenth century painting. To an art lover it was painted yesterday.

Art is either good or not. Relevance has nothing to do with it.

If you are lucky, people will buy
your art for the wrong reasons.

Art is art. The art market is a fashion business.
If the roulette wheel of fashion clicks into your
number, great, but never confuse the two.

Compromise to sell your art, but never
compromise the art itself. If you do, you are
no longer an artist, you are a manufacturer of
decorative goods.

That's OK, if that's what you want. Just be aware
of the difference.

When you break all the barriers,
you get a pile of rubble.

Absolute freedom is a paralytic blur of
possibility that amounts to nothing.

Limitation is essential for any clear expression
of human excellence. Creative freedom relishes
its limitations because it builds on them.
Restriction of means releases inhibition,
stimulates the imagination, and clarifies choice.

Innovation is toxic when it destroys conventions
it should be refreshing. Art is not breaking rules,
it is making rules.

Postmodernism is modernism
with amnesia.

Postmodernism shuns useful rules and
conventions and rationalizes inferior art by
wrapping it in words—a suit of armor with
no one inside. It thrives in the academy, where
language abandons reality to serve ambition, and
reputations rise on hot air. It is silly and joyless
at the same time.

Postmodernism seems to be fading away. Let's
hope! But when it comes to trendy intellectual
nonsense, academia is infinitely resourceful.
What will it come up with next?

An ivory tower is a fine place
as long as the door is open.

The charge of "elitism" is sometimes heard in the art world, but elitism is OK. All specialties are elitist. There's nothing wrong with that.

Art may be for the privileged few, but they have earned the privilege and deny it to no one.

When art writing seems incomprehensible,
chances are it is.

Many people have told me of being intimidated by some incomprehensible piece of artgarble.

Years ago, after I gave a commencement talk at a Midwestern art school, a student came up to me and asked me to visit his studio. I expected to look at his work when I got there, but instead he picked up an art magazine and asked me to explain an article. As I recall, it was titled "Transcendental Antifetishism."

"Good grief!" I responded. "Throw out the magazine and make art."

His relief was palpable. I left feeling that I had done a good deed.

A critic without an eye is like
an archer without a bow.

The ability to see underlies all criticism. It seems to be an inborn talent which can grow and improve with use. It is not only essential, it is rare (especially in the art world, alas) and clearly evident when expressed.

I once went around a large art collection with a prominent politician who had no art background at all. I expected it to be a chore, but he amazed me by not only picking the best work but also by saying smart things about it. He knew nothing about art, but he had an eye and he had the confidence to say what he thought.

Too bad he wasn't in the art business!

Ugliness in art is the last
refuge of the uninspired.

As art gets more popular and the market gets bigger, as it has in the years since World War II, competition increases. Art, which has no evident usefulness, is forced to shout, "Look at me!"

Art could try to be beautiful, of course, but beauty, by its nature, is rather soft-spoken and reticent, and the art public, in its persistent vulgarity, confuses repulsiveness with profundity. This fosters quantities of art taken to grotesque extremes.

Many years ago, Clement Greenberg said, "All profoundly original work looks ugly at first." This should be updated to "All profoundly ugly work looks original at first."

Great art doesn't care about you.

It just sits there and smiles, like the Buddha.
It will not solve your problems or make you a
better person.

It doesn't even care about all the dumb things
that are said to its face. Art that wants to be felt
does not have the need to be admired.

"If you want what I have," it says, "you are
welcome to it. If not, please move on."

Art rides in on pleasure.

The pleasure carries something with it,
something very precious to us that is inseparable
from the pleasure itself.

I live with that something every day, but I can't
say what it is. No one can. If you have an eye,
you comprehend it in an instant; you feel it and
you know it.

That's that.

Art is in the materials.

Don't look for it somewhere else.

When rhetoric elevates the spiritual over the material, art slips away and hides. As Oscar Wilde said, "The true mystery of the world is the visible, not the invisible."

Good art makes the material and the spiritual the same thing.

Art is making something better
without knowing what better is.

Making art is trial and error. You have to get comfortable making mistakes, because you will make mistakes. The trick is to know which ones to keep.

As Justice Potter Stewart said of pornography, you can't define it, but you know it when you see it.

Good new art may not look like art.

In my younger and more impressionable years
I was told by an older, more experienced artist
that Jackson Pollock was not a good painter
because he didn't use a brush. This was a
problem for me because Pollock looked good to
me. But he was right—those drips and splatters
sure didn't look like art.

They do now.

There is no sweat equity in art.

You can work hard, spend lots of time, and do all the right things—and end up with bad art or mediocre art or good art.

You can be sloppy, wasteful, and careless, and make something in five minutes—and end up with bad art or mediocre art or good art.

It doesn't matter. In art, the end always justifies the means.

Fun is profound.

I heard a colleague try to explain the joy of art to a student, but the student, convinced that art must be sober and unfrivolous, objected. "That's not profound, that's just fun."

My colleague responded, "Fun is profound."

This stuck with me, and I wondered why until I realized the obvious: Art is fun. Art gives pleasure, and pleasure delivers art. They are inseparable.

Keep your ego out of your art.

Years ago, I had the young painter's egotistic partiality for self-determination. No one was going to tell me how or what to paint.

Then a collector asked me to make a painting with a color in it that matched her new curtains and gave me a swatch of material.

What to do? This was a challenge to my beloved autonomy, and I didn't even like the color. But it was a good collector and a sure sale.

My resolve waned. I got the paint and used it in a painting. It turned out to be the best painting in the series I was working on at the time. I used the color in three more pictures.

The life in art arises from invention. Sometimes the best work comes not from using what you like, but from creatively incorporating what you think you don't like.

Mindless open-mindedness
is closed-minded.

People often respond to tough, specific, rational, logical, common-sense criticism of art not with a refutation of the argument, but with a retaliatory accusation of closed-mindedness.

Open-minded means that you consider something, not that you accept it.

As Lawrence Ferlinghetti said, if you are too open-minded your brains fall out.

A work of art is never finished,
it is abandoned.

Leonardo may have been the first to say this,
and it is still true.

A work of art is a living accumulation of creative
judgments. Each judgment is a reflection on,
and change to, the existing accumulation.

It is never quite clear when a work is finished
because it can only be finished when the artist
can't find anything to improve. Sooner or later,
however, it must be done with.

Creation, by its nature, is never complete.

There is no best way to make art,
but there are a lot of better ways.

If a best way was evident and could be specified, it would have been patented long ago.

On the surface we are each different. Deep down, we are all the same. Art comes up from that deep place.

Getting there is like going through a jungle to reach a gold mine. Every artist has to find their own path, but the gold at the end is valuable for everyone.

Talent without opportunity is like
electricity without a light bulb.

We like to think of the great artist as a solitary
tower of talent, rising from a cultural wasteland.

Not true. Genius is partially created by
and utterly dependent on all the peculiar
circumstances of the surrounding culture,
and its first job is to find the best vehicle of
expression available in that culture.

What would have happened to Mozart if he had
been born in the Middle Ages? Or 1975? Think
about it.

If you can say it, don't paint it.

Why bother? The valuable part of the work
is precisely what you cannot explain. Art that
needs an explanation is art making excuses for
its existence.

Just make the best art you can. If it is any good,
it will explain itself.

Good art carries a high density of choice.

Our culture is a massive structure of
accumulated human judgments going back tens
of thousands of years. Every work of art is a tiny
tip of a huge cultural iceberg. It is what an artist
starts with.

Then there is looking at other art, learning
technique, working out a method and trying to
make the art as good as possible.

Mondrian struggled for twenty years, through
realism, impressionism, fauvism, and cubism
before coming to his simple geometric paintings.
There may not be much in them, but there is a
hell of a lot behind them.

There's a big difference between grabbing
attention and rewarding attention.

The art business is fiercely competitive. This leads to desperate attempts to get attention. Sometimes these are successful in the marketplace.

But the test is whether you want to look at a work of art again and again, whether it stays fresh and alive. If you don't get a charge every time you see it, there is not much point seeing it in the first place.

An explicit measure of worth in art will
result in inferior art tailored to it.

When characteristics of superior new art are pointed out and described, those characteristics will be appropriated by artists who can't come up with something good on their own.

When this happens these features are no longer fresh, and they tend to be uncomfortable in their new home—an intruder that debases one's work even as it is pursued with all the zeal of a fresh idea.

Examples of this can be seen in the virulent spread of cubism in the years before World War I, as artists carved facets out of figures instead of using the method structurally, and in what was called the "Tenth Street Touch," as hundreds of abstract painters in the 1950s painted like Willem de Kooning.

Art is good by judgment, not inventory.

There are thousands of paintings of the Crucifixion. They all have the same highly charged, well-known content. Only a few persist as great art.

Why? Because most of them, although they may invoke the Christ story well enough, are not great art.

If art depended on content, then one painting of an apple would be as good as the next one. Why bother with Cézanne?

Look with your eyes, not your ears.

You hear all kinds of hype and hoopla and theoretical mumbo-jumbo about art, but the evidence is always there in the work, staring you right in the face. All you need to get it right is a clear eye and a little common sense.

We learn to lie, to others and to ourselves, by believing words rather than experience. Always be open; always be skeptical.

Saying that something is art
does not make it art.

It seems that just about anything can be art
these days, but calling something art is really
nothing more than a request for a certain kind
of response.

What counts is what happens when you ask it to
actually be art.

If that doesn't work, to hell with it. When in
front of the work, you are the only judge.

A painting isn't bad just because it
looks good over the couch.

We think it is demeaning and vulgar to treat art as decoration, and we go to great lengths to justify the art we like as "more than" decoration.

But good art is not more than decoration. It is simply good art which also may be decorative.

It is much more demeaning and vulgar to insist that the art we like is "disturbing" and "challenging" in an effort to demonstrate that we are somehow above common enjoyment and pleasure.

Writing about art is only useful to art
when it leads into the experience of art.

Art writing is wholly subordinate to art itself.
Its job is to describe, illuminate, report on, and
point to art of interest.

Writing about the art world—prices, gossip,
trends, and the like—can be quite interesting,
but it is less about art than the relationship of
art to other things.

Real art criticism only needs two words: go look.

Innovations in art are catalysts,
not conclusions.

True innovation in art is not making something
new and different but making something better.

Novelty rejects true innovation in favor of
obvious but superficial changes calculated to
get attention.

True innovation is thoroughly absorbed into the
object and cannot be considered apart from the
elements of the object.

There is only one measure for any innovation:
Does it make the art better?

Art is here to take us beyond language.

Good art has everything you need to know about it in the work, not on a wall label or in critical essays. These do not help aesthetic comprehension, they alleviate the discomfort of unfamiliarity by providing a substitute for aesthetic comprehension.

When someone asks a question about my painting, I always want to say, "Ask the painting."

There is no regional art anymore.

Back in the 1980s I noticed a magazine article about a large show of Australian art.

I had been to Australia recently and had seen some good new art, so I looked at it with interest. I was dismayed to see a collection of fashionable neo-expressionism which could just as easily been assembled in SoHo, and it dawned on me that anything new in art was now quickly assimilated everywhere else.

The only regions left are the art magazines and the internet.

Art is entertainment.

"No!" you say indignantly. "Art is more than just entertainment!"

Entertainment is disparaged as cheap and common, something below art.

This is wrong. Art is merely a kind of entertainment that brings us something we value very highly, and it is made for those who are entertained by it.

If you are not entertained by art, don't bother with it.

The art consensus is not a guarantee,
it is a convenience.

Art is the flower of a civilization, and our civilization cultivates it vigorously, choosing the best for public collections.

No one agrees with everything that floats to the top, but we do a pretty good job of it, especially with older art. If it is in a museum and in the art history books and has some age to it, that is reasonable evidence that it may be worthwhile as art.

But art does not become art until it is experienced as art, and it is not good art until you find it to be good art. Until then it is just an accumulation of materials, a thing called art waiting to be art.

Begin a work with a fresh idea,
then let its ideas replace your ideas.

If you know exactly what the final work will look like when you start it, you are not making art, you are illustrating an idea.

When making a painting, every change is a new picture. Each new picture demands a new evaluation, and the only thing that matters is what you do then.

Let the work be your guide.

You don't have to be a caveman
to appreciate Lascaux.

On a panel in Texas some years ago, my
Kantian assertion that good art was good
for everyone was challenged by a New York
critic who declared that a tribesman from
New Guinea certainly would not understand
abstract painting.

I responded that it was nothing more than a
matter of acculturation, and that I would much
rather discuss abstract art with a New Guinea
tribesman with intelligence and a good eye than
a New York critic who had neither.

Good art is good art. It just takes getting used to.

Always steal from other artists,
but never steal from yourself.

As Picasso is thought to have said, "Bad artists copy, good artists steal," succinctly illustrating the difference between servile imitation and the creative theft of a new technique.

I had a graduate student once who spent an entire semester painting large landscapes taken directly from Matisse. Everyone got on his case about it, but when the semester ended he had thoroughly ingested Matisse, and it serves him well to this day.

Endlessly repeating your own pictorial successes, on the other hand, is a failure of the imagination and will debilitate your art. Art makes you regularly reinvent the wheel or it gets bored and wanders off.

Art, like law, politics, people, and food,
should always be judged case by case.

In making or seeing art, everything comes down to the judgment of the moment. Every picture, new or old, hanging in a museum or sitting unfinished in your studio, is always brand new.

The only thing that counts in art is what happens the moment you experience it.

Good art is what it is,
not what you want it to be.

After years of talking about it, a collector finally bought one of my paintings. A week later he brought it back, apologetically saying, "It's a really good picture but it just doesn't go with anything in my house."

"Well," I said, "maybe you should get rid of what you have in your house."

Your habits are always at war
with your imagination.

Studio experience leads me to wonder if a large part of talent may be the ability to take one's everyday habits, good and bad, and throw them out the window. "I did it my way" does not mean you did it the best way.

Hans Hofmann was inventive, hyperactive, and productive. These characteristics often led him to kill a painting by overloading it. Late in life he learned to either leave a painting "unfinished" or paint large rectangular slabs over the excess. Both things went against his nature, and they were his best pictures.

Go with your gut instincts, but recognize when they are wrong.

There is nothing as worthless as bad art.

As Oscar Wilde said, art is quite useless. You can't eat it, drive it, or live in it. Its uselessness, however, is what allows it to be a pure vehicle for human value. Great art has something we cherish very highly, but history tells us that very little of the huge quantity of art that gets made does what art is supposed to do.

Nevertheless, much of this detritus is eagerly bought for lots of money. The numbers tell the story.

We are a strange species.

Science and art are not opposed,
they are just different.

Science adjusts language to explain reality. Art adjusts reality to understand life. One generates proof. The other generates pleasure.

Both are utterly dependent on imagination.

When painting a landscape, assume
the painting is real and the landscape
is an illusion.

After all, the one real thing you have is your
experience, and the painting comes from
that experience.

The landscape is just something you are
looking at. If you turn your head—poof!—
there's another landscape.

Live to paint, don't paint to live.

If you can make a living from your painting, that's wonderful, but there may be a price to pay.

Branding is important in the market. Collectors get used to a "look" and they don't want it to change. You can watch your audience evaporate as your art gets better. Then you have a tough choice to make.

True art making is making art as good as you can make it. Don't let anything mess with that.

When making a painting,
only one thing counts:
what you do next.

The next thing you do to a painting changes the painting, and that choice was made with every previous change right in front of you.

Ask yourself: Did I really evaluate the whole picture every time I made a change? Or did I just put some paint where there wasn't any, or because I had some left on the brush, or because I had a plan I didn't want to alter?

You make a thousand new paintings to make one new painting, and you need to fully comprehend each one.

The power of art is not communication,
but effect.

When you sit down to a good meal you don't ask, "What does it mean?" You taste it, you enjoy it, you consume it, it goes deep inside and nourishes you and makes you feel better. It helps keep you alive.

That's what good art does.

Art captures life.

I have always felt that the much-discussed
structure of Cézanne's paintings and the cubist
pictures that came out of them, which are so full
of staccato impressionist marks, is really just a
visible foundation for the living vibration that
the structure supports.

It seems to me that all the various elements
of any good art are in the service of capturing
something perpetually unresolved, like a furious
bee in a bottle. Like life itself.

Paint, don't think.

This is what I say when I see a student sitting passively in front of unfinished work. Painting is action: paint, look, paint again, look again. If you are not in the thick of it, go have lunch.

A former graduate student recently thanked me for this, telling me that his studio time had been polluted with racing thoughts of the art world and what other people think and other such useless ephemera. Now he just leaves it all at the door, thinks about nothing, and paints.

You can see it, but you can't say it.

The first project in my writing class is "Describe a thing: Write about some small object using no names of any kind. Bring it to class and keep it hidden while you read your description. See if anyone can guess what it is."

Sounds simple; it isn't. After much struggle and guesswork, the object is exposed and everyone says, "Oh . . . of course!"

Crafting a page of words to visualize a common object is difficult. Saying why something is good or not so good as art is hopeless.

The only thing that makes a work of art good is the work of art.

We all have ideas about what a work of art should look like. We hold onto these biases even as we try to suppress them. We push our egos on our art as we make it and become blind to true innovation when we see it.

When making art, any particular characteristic of the art only has one function: to make the art better. The work itself will tell you what that is. It is not easy, but it is all you need to know.

Facts and common sense interfere
with our systems of denial.

We give lip service to facts and reality, but in the real world these things take second place to what we choose to believe as we build our shelters of shared ideology against the chaos out there.

We are a tribal species. Reason and common sense are easily exorcised when art becomes a ritual object of a ceremony of belonging.

Take yourself away from the art world as you know it, as if you just woke up, like Rip van Winkle. Then examine a catalog of any recent sale of contemporary art at Christie's or Sotheby's. Look at what is selling for hundreds of thousands of dollars and ask yourself, honestly, would I put these things in my house? What makes anyone want to, and at such prices?

Making art is not risky.

Any true artist will immediately object to this. Why? Because making art feels so risky. After all, you are putting heart and soul on the line.

When you are serious about your art, every perceived little success must be preserved, every perceived failure is a testament to your abject lack of talent, and every hesitant, anxious new stroke of paint betrays your meager ability and exposes you to ridicule.

Put a stop to this. When making art, forget you are making art. Tell yourself you are working with a few dollars' worth of disposable materials, trying to make something you and maybe some others will like to look at, something nice to pass the time.

It probably won't work, but it's worth a try.

Inspiration doesn't follow style,
it creates it.

Good artists don't imitate existing art, they rework the useful elements of existing art by inventive recombination, thereby giving these elements new life.

A good example would be the varied handling of the impressionist dot-and-dash stroke in postimpressionism, fauvism, and cubism.

Invention—making it new, not just "different"—is the spark of life in art, and it is why good recent art often doesn't look as much like art as we think it should.

Talent is a seed that needs fertile soil.

Talent is the innate ability to put something into effect, abetted by a good working attitude and driven by an appetite for hard work.

Talent itself cannot be taught, but what talent there is can be helped along. Good teaching helps. More important, and much less recognized, are the myriad intangible attributes of the environment—what is "in the air"—that we see in the English language in Elizabethan times, classical music of the late eighteenth century, fauve painting and cubism in the first years of the twentieth century, jazz in the 1920s and '30s, and other rare circumstances.

The seeds of talent are always present. As in nature, something must be there to nurture them.

Planning is fine. Preparing is better.

Larry Poons once said to me, "Setup is everything."

Making art is a state of continual invention.
Invention causes change and subverts planning.
You cannot know what is going to happen, so
you'd better be ready to do the right thing at the
right time.

I always have a plan for my next painting, and
part of my plan is to abandon my plan as soon
as it crumbles. My materials, however, are always
right at hand, ready and waiting.

When inspiration dies, imitation thrives.

In academia it is said that to steal from one person is plagiarism, but to steal from many is research.

In the art business, when one steals it is influence, when many do it's a trend, and when it goes over big it's fashion.

Imitation, like so many things, becomes reputable as it becomes conventional.

When anything can be art,
art is not much of anything.

In 1917 Marcel Duchamp bought a urinal, signed it "R. Mutt," and entered it in that year's exhibition of the Society of Independent Artists in New York. It was the opening skirmish in the populist campaign to demystify art. ("De-deify" in Duchamp's words.)

The battle is over. The "elitists" have scattered. Criteria are laughably passe. Art is whatever rides the waves of fashion.

Certainly everything should be available to art. But when a discipline loses touch with itself, standards melt away, and the enterprise becomes not demystified but demoralized.

When the obvious is made mysterious, the mysterious becomes unavailable.

Art-making is just a lot of tricks and devices.

So is any skill—cooking, baseball, politics, robbing banks. If you don't learn the methods, you are not making art, you are making claims.

What really matters is how you use those skills. In art, there are no guarantees.

Originality is overrated.

To make you need to take. All great artists do.

You can choose to be different—this is
commonplace these days—but you cannot
choose to be original. Originality is less a matter
of "newness" than a byproduct of accepting what
is available and making it better.

If you have no place to go, stay home.

Beauty gets a bad rap.

The dominant vulgarity in the art business is not Elvis-on-velvet or Thomas Kinkade cottages or dogs playing poker, but the habit of adulterating art with "meaning" because beauty is confused with prettiness and therefore "not enough" for serious art.

Scientists are smart people. When they are impressed with a brilliant theory, they call it "beautiful." We should not surrender our territory so easily.

When it gets easy, get busy.

Often I will praise a passage in a student's work, only to hear, "But that was so easy. It only took me a few minutes!"

They assume that to be any good, art must be hard-won.

Yes, art is hard. But sometimes you get in a groove and things start humming. Trust it, grab it, and run with it. It won't last.

Making art is like swimming underwater
while wearing a blindfold.

When you are truly making art, you are out of this world, with all its safeties and certainties. By being free of real peril, art-making plunges you into a simulation of peril, where you anxiously thrash about with little to guide you but your experience, a sense of purpose, and an often uncooperative, mutating thing staring back at you.

If you think you know what you are doing, you are probably fooling yourself. And if you are a real artist, you do it anyway.

If it doesn't begin as feeling,
it doesn't end as art.

This is a paraphrase of a quote from Cézanne, who knew what he was talking about. I might substitute "intuitive guesswork" for "feeling," but it amounts to the same thing.

Scientists and philosophers who explain art do not understand this. They have it all worked out and are very assertive about their reasons, unlike us poor, confused artmakers, who know better.

There are no reasons, of course. There is only the artist, the "rainbow of chaos" (Cézanne again) and the art itself.

You can't learn to be a good artist,
but you can learn to be a better artist.

When I was a Little League coach, we would ask a new kid to run to first base. By the time they got there we had a pretty good idea of their athletic ability. We did not, however, know their ambition. That took time.

It is much the same with art students. The basic talent is whatever it is, but ambition is the engine which drives it. As teachers, we are in the passenger seat with one hand on the steering wheel. All we can do is see, guide, encourage, and do our best to prevent serious accidents.

"Art for art's sake" means
art for our sake.

"Art for art's sake" was a slogan of the nineteenth century aesthetic movement. It meant that art's value stood apart from moral or utilitarian use. Its awkward wording (think "food for food's sake") helps it to be misunderstood to mean that art stands apart from all human concerns.

Art, like many things, can be used for whatever one wants to use it for, but the source of its value is aesthetic. It delivers a kind of pleasure which brings us something profound that we can't put into words. This is what the phrase really means. It is as "human" as anything can be.

There is so much cultural evidence for this that the misuse of the term, which is all too frequent, is usually evidence of bad faith.

Too much freedom is a dangerous thing.

Freedom is the illusion of unimpeded choice. I say "illusion" because once we make choices we are thereby less free. What we call freedom is really the right to restrict our freedom in our own way.

Today, much "advanced" academic art instruction teaches that the acquisition and exercise of art-making skills hinders artistic freedom, because the artist must remain unburdened and pure to allow inspiration to flow like an unobstructed torrent.

This is destructive nonsense. It is like telling a baseball player that learning to hit the ball hinders their athletic freedom. Art, like any specialty, is a matter of perpetual learning and choosing. When you narrow down and get in a groove, you don't limit possibilities, you find new ones.

If you like everything, you like nothing.

Oscar Wilde said that only an auctioneer can equally and impartially admire all schools of art.

Much that we see in galleries and museums is clever, decorative, or otherwise amusing. But it is only art when you ask it to be art, and, as art, most so-called art is just surface noise. If you like it as art you are not looking hard enough.

Like whatever you want to like, but be careful what you call it.

An argument about art is not won
until it helps someone see.

Like so much else, art is argued over endlessly and fruitlessly.

Much of the talk is not about art as such, but things peripheral to art. If the discussion is about specific good art, and you can somehow trigger a better comprehension of that art in someone, then some actual work gets done.

In such a disagreement the loser is the winner.

In art, as in life, the best way to remedy
mistakes is to take advantage of them.

The nice thing about art is that it is much easier to deal with mistakes. In life there are consequences. In art, you just cover it up.

But covering up the mistake may be a mistake. Step back and check it out. Is it actually telling you something you don't want to know about your art?

Opportunity is always knocking, but you have to hear it.

Making art is like making love.
If you think about "meaning" you lose it.

My wise friend Jules Olitski came up with
that one.

Those who do not comprehend art have always
tried to "get it" by applying literal meaning to
it. Many artists now busy themselves making
art that accommodates this unfortunate habit.
Thus we have art which consists of ordinary
things burdened with cultural baggage, less
works of art than visual expressions of shared
and conditioned attitudes, sets of clues leading
to talk.

We call this stuff art, and it is indeed
"understandable," but when you look at it as art
it goes dead.

Recognize good art, don't identify it.

Art has very high social prestige. However, most people can't tell the difference between good art and bad art. Therefore there is strong social pressure to find ways to know the difference.

This leads to absorbing what is said to be good art in books and museums. We learn what Rembrandt and Monet and Picasso and Pollock look like, and put these characteristics under the heading of "good art."

Unfortunately, this often leads not to an improved ability to recognize what is good, but to an association of goodness with style. This, in turn, leads to fashion rather than discrimination, especially in contemporary art.

Seeing art, like making art, is a talent in itself. If you feel it, you get it. If you don't feel it, art is not for you.

Always let intuitive perception
precede analysis.

Walking through a friend's house one day,
I spied a small painting on a back wall. It
immediately struck me as a very good picture,
and my instant thought was, "What is *that*?"

A second later I realized that it was a painting of
mine which I had given him years before.

This kind of positive affirmation is a thrill for
an artist. It is how art should be seen. If I had
known it was my picture before I saw it, I
certainly would have fallen into my surly habit
of picking it apart and finding fault.

Look at all art with fresh eyes. It is not easy, but
it is essential.

The road to bad art is paved
with good intentions.

"What we must discern," says the museum docent, "is the intent of the artist."

Ugh! I cringe. That holy of holies, the "intent of the artist"!

My students don't get away with that stuff. If they try to justify something that doesn't work with "but that's what I meant to do," I tell them to hell with intentions. There is only one thing that counts, and that is the work itself.

Self-indulgence does not bring out the best in us. Working through difficulty does.

Art is not truth.

Truth is expressed in words; art is expressed in feeling.

Truth conforms to reality; art invents reality.

Truth is subject to proof; art has nothing to do with proof.

And so forth.

Yes, I know, "Art" and "Truth" are both noble and high-minded and all that, and therefore they are often associated, in a hopeful way. But they are apples and oranges.

Clarity is important. Keep things where they belong.

Listen to your materials, not your ego.

Years ago, a ceramics instructor tried to show
our class the limits of stoneware clay by turning
a bowl on a wheel until it collapsed.

The bowl grew ever bigger and thinner, and
the instructor became more and more annoyed
because it wouldn't cave in. Finally, I begged her
to stop trying to ruin what had become a very
beautiful form and let me glaze it. Reluctantly,
and with obvious irritation, she agreed.

When I came the next day the bowl lay
crumpled in the waste bucket.

Don't replicate your art,
replicate yourself.

When you have made a good painting, it is tempting to start a new painting in the same mode. But things change. What you have brought over from the first painting may not be in sync with what is happening in the new painting.

Try starting not with the visible forms of the successful picture, but with a memory of the process, what your attitude was, what you were thinking and feeling.

The new picture will not end up looking like the earlier one, but it may end up better.

You cannot justify good art,
you can only promote it.

Art cannot be justified in words. It goes from feeling to feeling, unobstructed by explicit measures of value. It is measured entirely by its effect, which is neither quantifiable nor definable.

This does not mean that art is "just a matter of taste." Taste is not the determinant of goodness, it is the pathway to it. When you get there, you don't have to say why something is good art. All you have to do is point and say, "That is."

All art is abstract art.

The realist/abstract distinction in visual art is a useful one, but it is not precise. The most "realistic" photographic representation is abstracted ("taken from") the thing represented, and the extent of representation is always a matter of degree.

Non-representational visual art is new to our civilization and remains controversial. It is less a matter of discarding realism than a condition of change caused by intrinsic demands of modernist innovation. It confirms Walter Pater's contention that "All art constantly aspires towards the condition of music." Eventually it will no longer be an issue.

I wish it would hurry up and happen.

Art is imitation of nature.

Seneca said this two thousand years ago. It is usually taken literally, to mean that art represents things we recognize.

Maybe it goes deeper than that. When realistic images or patterns are seen in an abstract painting, they are often parallels brought about by processes in painting which echo processes in nature.

Furthermore, I have noticed that procedures in art-making resemble those in nature, particularly evolutionary nature. Certainly the aesthetic attitude reflects the specialized, simultaneous attention to the whole and to minute detail that nature insists on for all life.

Everything around us, everything we are, and everything we do has evolved together for millions of years. We have more in common with a rock than we think.

Every artist needs a good friend
with a good eye.

I have long been aware how blind I get to my own work. My brain-eye coordination seems to get stale after a few hours working, and I begin to rely on intention rather than invention. Other artists tell me they have the same problem.

Find someone with a good eye who can and will tell you if your work is working. It may be painful, but if you are serious about making art you are a masochist already, so just enjoy it.

Words point to reality. Art is reality.

The nature of language demands that the actual substance of any discussion is absent from it. We are a talking species, so we think of language as specific when it is actually only symbolic. There is a world of experience obtained by holding a cold stone in your hand that is utterly beyond language.

Felix Mendelssohn wrote, "The thoughts which are expressed to me by music that I love are not too indefinite to be put into words, but on the contrary, too definite."

In art there is no absolute good or bad, but
it is absolute that there is good and bad.

Anyone who is truly engaged with art knows the hunger of the art lover for the best. The experience alone erases any doubt and starts one on the hunt—listening, looking, sorting out.

But I have found that it is a precarious indulgence to judge between masterpieces. Who is the greatest artist? What is the best painting, book, poem, play, piece of music? It doesn't matter. The loss of any of it would spoil my hoard of beautiful things and make a hole in my life.

Life is more important than art.

Clement Greenberg used to say this on occasion.

In college I was listening to Glenn Gould play
Bach when a brilliant composer friend came into
my room to visit and asked me to shut it off.

I was shocked. "Why turn it off? I thought you
really liked Gould. It's great music!"

"I know," he responded. "I'm just tired of music
right now."

I still remember that. It taught me something
that seems stupidly obvious but which I needed
to comprehend. Nowadays, though art is my
life's work, I freely admit that occasionally I get
sick and tired of it.

Good art is not made in the spotlight.

When you are making art there are no galleries, dealers, critics, crowds, museums, or professors. You are all by yourself, with your work, in another world. The only other person involved isn't there: the one who will see it.

Good art is not extravagant public display. It is the effective sharing of private delight.

When everyone is avant-garde,
there is no avant-garde.

A hundred years ago people started noticing that artists who did unconventional work—work that was derided, rejected, and unbought—turned out to be the best artists of the time.

This perception trickled down, and soon the idea of innovation caught up with innovation itself. Artists struggled to "make it new," as Ezra Pound famously advised. Critics, fearfully aware of those who disgraced themselves by laughing at Cézanne, hedged their bets by criticizing only that which appeared traditional.

Unfortunately, when everyone is "making it new" we get mindless novelty abetted by critical cowardice, and the enterprise of art-making descends into willful eccentricity. As Goya put it, "The sleep of reason produces monsters."

Just paint.

When some aristocrat asked him to write a piece
of dinner music, Mozart willingly dashed off a
divertimento. It may have been written quickly
for fast money in an easy key, with a viola part
kept simple to fit the aristocrat's limited talents.
But it was great music because Mozart wrote it.

Art flows much more easily when you are not
worrying why you are making it, whether
someone will like it, or how it fits in with what
is out there in the art world. As Yogi Berra said,
"You can't hit and think at the same time."

You don't know nothing.

Yogi Berra said that too, about baseball, but I'll say it about art.

The impressionists taught us to look, not to think, and to paint what we see, not what we know is there. They looked and they saw spots of color, and that attitude, and those spots of color, led to postimpressionism, which led to Cézanne and cubism, and cubism revolutionized painting.

So, no sooner did art get truly realistic than it rushed headlong into abstraction. Who knew?

Don't explain, enjoy.

Art that can be explained is not art, it is an illustration of an explanation.

As Oscar Wilde said, the moment you understand a work of art, it's dead for you. As long as it is giving you simple pleasure, it is as alive as you are.

Seeing the real thing is the real thing.

Ninety-five percent of the art we see is seen in reproduction. This is how the art business is conducted. Most characteristics are visible in the reproduction, but subtlety, surface, and scale are lost. Much good work looks terrible reduced on paper and much bad work looks way better than it should. The advantage goes to the bad stuff.

Art is there for nourishment, not efficiency. Would you go to a restaurant that served menus but no food?

Great art is like a stone in the river.

Janet Leach said of Shōji Hamada's *shibui* pots,
"They just sat there like stones in the riverbed.
They did not perform. They did not reach
out and grab you. They were fulfilled within
themselves and did not seem to care whether
you liked them or not."

Great art is immutable, placid, complete,
unchanging, and content to let life rush around
it in its perpetual race.

Art is as persistent as it is fragile.

When I was a kid, I used to wonder why life just went on and on. I asked my father, "Why doesn't my heart just stop once in a while?" He didn't know. I don't think anyone does. When something is evident and real, we just accept it.

Now I wonder how art persists. How does it just keep going, year after year, and get treated so respectfully, when no one can tell us why we even need it, and so few understand it or know the difference between good art and the detritus that is called art but is not art?

The marketplace bustles, changes, and is lost in history. But art, which is as fragile as life, keeps reviving and adapting, telling us what's good about us. Apparently we need it.

When bad use is made of a good idea
it is the fault of the user, not the idea.

Periods of great art, like periods of great
civilization, are not initially undermined by
outside enemies but from the inside, like the
microbes which kill themselves making alcohol
for wine.

Once inspired artists establish a method, lesser
artists use it to cater to an audience who like
the idea of art, and want it to be called art,
but prefer something vacuous, contrived, and
dramatic. This debases the original forms, which
then become dated and unfashionable.

The ache for the ordinary is often cloaked in the
guise of the exotic—a sheep in wolf's clothing.

Without the eye, the head is blind.

Without the head, the eye is adrift.

An exaggerated distinction but a true and useful one. The eye sees; the head evaluates. Too much eye and judgment collapses. Too much head and paralytic reasoning creeps in.

This goes on when making art or seeing art, back and forth, like mental ping-pong. When you play hard it is exhausting, but there is no other way.

Lucky for us, great art itself is inexhaustible.

Afterword

by Franklin Einspruch

Walter Darby Bannard, "Darby" to those who knew him, played a crucial role in the history of postwar American art. His paintings have been the subject of hundreds of shows, including "The Responsive Eye," the seminal exhibition of abstraction at the Museum of Modern Art in 1965. They reside in museum collections from the Whitney Museum of American Art in New York to the Centre Georges Pompidou in Paris to the National Gallery in Victoria, Australia. His own writing on art was no less widely seen, published in journals such as *Art in America* and *Artforum*, as well as in the *New York Times*. Along with the influential critic Clement Greenberg, who became a lifelong champion of his after they met in the late 1950s, Darby was one of the great intellects of modern art, whether he was analyzing it or creating it himself.

Darby began working in a minimalist mode before *minimalism* existed as an art term. His paintings from the start of his career in the late 1950s and early '60s remain highly sought-after objects. They are simple affairs, sometimes consisting entirely of a circle on a human-sized canvas. Yet they possessed enormous presence, and Darby came to call them "presentational abstraction." This was a form distinct from both the perceptual abstraction of cubism and the formal abstraction of the Bauhaus. Instead, it arose from the materials, establishing itself as an autonomous creation with no function except its own existence. It is an abstraction of physical realities: paint, surfaces, and the implements for conveying one to the other.

Frank Stella, Darby's friend and classmate while both were undergraduates at Princeton in the mid-1950s, was focused on something similar. While Stella's paintings at the time were monochromatic, or used paint straight from the jar, Darby never relented in his commitment to the evocative power of color. The palette in his works from the '60s, though formed from simple arrangements of warped and skewed quadrilaterals, connects visually to Monet's water lilies and Whistler's nocturnes.

The next fifty years of Darby's production defies any kind of convenient characterization. They

are all, to be sure, abstract paintings. But the
only reasonable way to group them stylistically
is by tool. In the works from the early 1970s
one can detect the distinct edges of masking
tape, removed after having been splashed with
various colors (using, as it happens, diapers).
Paintings from the later '70s evince his discovery
of squeegees, with which he would shove high
volumes of acrylic gel around on a stained
surface. In the late '80s he added brooms to his
arsenal, which would give him a similar sense
of movement that the squeegees provided, but
with dynamic streaks cut into the paint. In the
'90s he made numerous works on paper inspired
by the South Florida landscape, into which he
was introduced when the University of Miami
hired him to chair its Department of Art and
Art History. When he returned to painting
on canvas in that decade, he produced what
might be thought of as his orchestral works,
employing all the aforementioned methods
and an exciting range of pouring, brushing,
and flinging of paint in myriad opacities and
viscosities, alternately spreading and corralling
it into powerful compositions.

While a painter first and foremost, his verbal
acumen drew him into the debates of his time.
He wrote movingly in favor of the art with
which he was associated, termed *modernism*.
"Modernism" typically refers to the abstract

painting and sculpture made during the middle decades of the twentieth century. A more thorough understanding relates that art to creative impulses that emerged around the time of the impressionists, and carried forward through postimpressionism, cubism, and the early expressionist and symbolist movements. For Darby, modernism was something still greater and far-reaching: a pursuit, for its own sake, of visual excellence, which could not be defined but could be felt and experienced. "Postmodernism," as Darby used it, refers to art that shirks that difficult pursuit. As he wrote in *Arts* magazine in 1984,

> If modernism and postmodernism are unitary enough to characterize, I would suggest that it will be useful to see them as working attitudes. Modernism uses self-criticism to aim at and maintain high standards. Postmodernism asserts that these things are unnecessary for art. In spirit, modernism is aspiring, authoritarian, hierarchical, self-critical, exclusive, vertically structured, and aims for the best. Postmodernism is aimless, anarchic, amorphous, self-indulgent, inclusive, horizontally structured and aims for the popular. Modernism is idealistic; postmodernism is political. Each proceeds from and represents a side of human nature.

This is arguably unfair to postmodernism. Especially by 1984, many artists, including artists of great probity, found the historical trappings of modernism restrictive and shop-worn and they struck out in other directions. By now, postmodernism too has developed its own historical trappings. But Darby split the terms *modernism* and *postmodernism* apart from particular styles of art, in order to point to differences of approach. That was prescient and useful. One can make an abstract picture in a postmodernist manner, or a video installation in a modernist one. Styles come and go.

What persists is quality, the goodness of "art *qua* art," as Greenberg worded it. Writing in the *New York Times* in 1972, Darby insisted, "As always, there is only one real difference, the difference of quality, the difference between good and bad. That is the way it always has been, is now and always will be." Modernism had a tendency to produce quality and postmodernism had a tendency to get embroiled in some other concern, but neither guaranteed it. Writing for *Artforum* in 1969, he said that "the 'avant-garde' features" of the work of Willem de Kooning, a consummate modernist, "seem to have been applied by ambition for extra-art purposes."

Consequently, the question remains of what fosters quality and what does not. That in turn

challenges the artist to act accordingly. An unpublished essay of his from 1989 records these thoughts:

> Goodness as such is not identifiable. It is not substantive; it has no characteristics. Artistic goodness is a result of particular judgment and has life or existence only within a setting of that judgment . . . Art has been developed to exclude explicit measure. That is the kind of thing it is. There are no standards of reference, only experience, acculturation, development of taste and other preparations for judgment. Outside of that judgment all art, good or bad, or new, is not art, not good in itself, but strictly speaking, objects identified as art waiting to be art.

Darby's broadsides against postmodernism are a proxy war against dogmatism, in particular the idea that you could make successful art merely by following certain conventions. Modernism developed a dogmatic aspect, as Darby pointed out regarding de Kooning. But the reply need not have been a counter-dogmatism. Darby's modernism was perpetually unsure and searching. Postmodernist art tended instead to trade search for mere declaration. Hence his second aphorism in this book, "Art is not 'about.' Art is." This is in response to

all the works of art declared by their creators or interpreters to be about Issue X or an exploration of Concern Y or an analysis of Topic Z. Art can be turned into such things, but the surfeit of art that accomplishes nothing greater is plaque upon the arteries of human flourishing.

At this point the reader might protest: modernism and postmodernism aside, we live in a world that has conceptual art, earth art, performance art, social practice art, and other forms of art in which the visual is one component among other, possibly more important concerns. How does Darby's wisdom, born of painting, apply?

As it happens, Darby's early artistic ideas as a student at Princeton were wild. One project, never realized, entailed fashioning a hot air balloon into the shape of a figure from de Kooning's "Woman" series from the early 1950s. The concept was to fill it with hydrogen, launch it at dawn, and fire tracer bullets that would detonate it in the light of the sunrise. His forays into serious artmaking included Pop Art and what he called "event-type art," what came to be known as Happenings. He subsequently found in abstract painting a way of imposing a similar kind of raw, expectation-defying art experience on the viewer.

His example bears on the present. For one, it is permissible and potentially fruitful to go "backwards," as it may, in fact, be forwards. Second, it is important to discover your strongest interests and attend to them faithfully, even if it means defying others' expectations, or your own. Third, if you're engaged in an activity that can be executed in a better or worse way, you must discern the true mechanisms of its being better or worse, and act on the discernment. (And if the activity has no better or worse executions, then why are you doing it?)

One of the tropes of modernism is "the eye," not as a physical organ but as a sensibility that inclines towards good visual experiences. "A critic without an eye is like an archer without a bow," says one aphorism. "Look with your eyes, not your ears," says another. And again: "Every artist needs a good friend with a good eye." "Without the eye, the head is blind. Without the head, the eye is adrift." And my favorite example, from one of the commentaries, "I would much rather discuss abstract art with a New Guinea tribesman with intelligence and a good eye than a New York critic who had neither."

There is some dispute about whether "the eye" is a real phenomenon, and if it is, of what it consists. For those who accept it, it is some

aggregate of nature and nurture that causes an observable phenomenon, taste, which itself hasn't been pinned down very well. Taste, which is the ability to detect quality, raises the question of whether quality is an objective reality or a subjective artifact of experience. That further raises the question of whether the objective/subjective split is valid.

As stated in the foreword, this book of aphorisms is not meant to be sound as philosophy. It is meant to help you make better art. Nevertheless certain kinds of contemporary art overlap with philosophy, or its kid brother, politics. Many of the newer forms are not patently or exclusively visual. Their practitioners are skeptical about the notion of "the eye." If you are inclined to make such idea-driven work, or semi- or non-visual work, some of the advice in this book may not be wholly appropriate, but go and investigate it for yourself. Make that art in earnest and to the utmost of your ability. Darby would have told you as much. (Darby, in fact, often gave effective advice to students about how to better shape their art so as to impress teachers with entirely different priorities than his. He often knew those teachers better than they knew themselves.) Use all your perceptual organs, including your brain, with the intensity and probity with which Darby exhorts you to use your eye.

If you're not inclined to make that sort of work, consider this book a permission slip to be excused from doing so. The story attached to the aphorism "When art writing seems incomprehensible, chances are it is," speaks to the pressure to adopt the philosophical attitude. "Throw out the magazine and make art," Darby tells a student to the latter's great relief. Philosophy will never make your art better. Only making art will make your art better. If someone thinks you out of touch with the current trends, you will at least be in touch with yourself. Your eye, which as far as this book is concerned is as real as your arm, will sharpen.

We're going to have art so long as people continue to feel. It's likely that new, good art will come up in a milieu that in no way resembles the one in which Darby rose to prominence. Darby himself knew this. Later in the previously cited *New York Times* essay, he noted,

> Materials are only vehicles, inspiration is deeply human and ever persistent. It will always come up in the "wrong" place, and it will always be resisted and misunderstood. Great art, new or old, will not compromise, but it is always there, waiting for us to come to it. It is the flower of our civilization and, ultimately, its salvation.

There are people who know this in their bones. They are the searchers. Whoever they are and whatever they make, they will find in Darby an ancestor.

Acknowledgments

Dozens of supporters of both Darby and the broader modernist project made this volume possible, but I single out two people for recognition. The first is Kathleen Staples, who attended to Darby with great tenderness in their marriage and continues to nurture and protect his legacy. I cannot thank her enough for her graciousness regarding this effort to commit Darby's wisdom to print.

The second is Christine Berry of Berry Campbell Gallery, whose steadfast support of Darby's artistic and intellectual accomplishments extends to this book. I cherish her kindness and friendship, as well as her astute eye for artistic triumph.

As its editor I dedicate this volume to John Link. John was a longtime friend of Darby's who taught at Western Michigan University and was an exceptional painter in his own right. Darby's and John's exchanges in the comment section of

my blog, Artblog.net, grew so voluminous and rich that I finally suggested to Darby that we distill his remarks into a more readable form. That was the genesis of this book. It is Darby's thinking, but Darby initially set it down because he had John to riff off of.

John passed away unexpectedly in early 2021, before I had a chance to tell him that the stars had finally aligned for *Aphorisms for Artists* to see publication. Nothing mitigates my sorrow about that except to keep painting.

—Franklin Einspruch

About the Author

Walter Darby Bannard (1934–2016) was one of the foremost painters of American abstraction.

As a student at Princeton University, Bannard worked and looked at art alongside Frank Stella and Michael Fried. Bannard subsequently became associated with the later developments of abstract expressionism, and befriended the renowned critic Clement Greenberg.

Bannard's work was included in hundreds of exhibitions, including the seminal "Post-Painterly Abstraction" exhibition organized by renowned critic Clement Greenberg at the Los Angeles County Museum of Art in 1964, as well as "The Responsive Eye," held at the Museum of Modern Art in 1965. Bannard subsequently won a Guggenheim Foundation Fellowship and a National Foundation of the Arts Award. Bannard's paintings reside in many museum collections around the world, including the Metropolitan Museum of Art, the

Museum of Modern Art, the Whitney Museum of American Art, the National Gallery of Art, the National Gallery of Victoria, Australia, and the Centre Georges Pompidou in Paris. His art is represented by Berry Campbell Gallery in New York City.

Bannard was also an art writer of unusual lucidity. His numerous essays appeared in *Artforum*, *Art in America*, and the *New York Times* among dozens of other periodicals. He curated and wrote the catalog for the first comprehensive survey of Hans Hofmann for the Hirshhorn Museum in 1976 and contributed to a 1993 monograph on Dale Chihuly.

Bannard joined the faculty of the Department of Art and Art History at the University of Miami in Coral Gables, Florida in 1989, where he chaired the department until 1992. He continued to teach there until his death in 2016.

About the Editor

Franklin Einspruch graduated from the
Rhode Island School of Design with a BFA in
Illustration, which included a senior year in
Rome as part of its European Honors Program,
as well as study at the Aegean Center for the
Fine Arts on the island of Paros in Greece. He
became a graduate student under Walter Darby
Bannard at the University of Miami, where he
earned an MFA in Painting.

Einspruch's art has appeared in more than
sixty exhibitions. He has been a resident artist
at programs in Italy, Greece, Taiwan, and
around the United States. His 2019 Fulbright
award appointed him as the Fulbright-Q21/
MuseumsQuartier Artist-in-Residence in Vienna.

Einspruch has authored hundreds of essays and
art reviews for many publications including *The
New Criterion* and *Art in America*. He is the
editor of the archive of Bannard's writings. From
2017 to 2021, he produced Delicious Line, an

online magazine that published 500 art reviews by ninety authors. He has been blogging about art since 2001.

Einspruch is associated with the comics poetry scene that emerged in the mid-2000s. In 2012 he compiled the first anthology of comics poetry, titled *Comics as Poetry*, with a foreword by the poet William Corbett. He since published a book of his comics poems, *Cloud on a Mountain*, under his own imprint. "Regarding Th.at," his Fulbright project, was published online and reviewed in the *Boston Globe*.

He lives and works in rural New Hampshire.

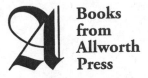

Books from Allworth Press

Allworth Press is an imprint of Skyhorse Publishing, Inc. Selected titles are listed below.

The Business of Being an Artist, Sixth Edition
by Daniel Grant (6 × 9, 288 pages, paperback, $19.99)

Legal Guide for the Visual Artist, Sixth Edition
by Tad Crawford (8½ × 11, 336 pages, paperback, $35.00)

Business and Legal Forms for Fine Artists, Fourth Edition
by Tad Crawford (8½ × 11, 160 pages, paperback, $24.95)

Art Without Compromise
by Wendy Richmond (6 × 9, 256 pages, paperback, $24.95)

Artist's Guide to Public Art: How to Find and Win Commissions, Second Edition
by Lynn Basa (6 × 9, 240 pages, paperback, $19.99)

Selling Art Without Galleries: Toward Making a Living From Your Art, Second Edition
by Daniel Grant (6 × 9, 288 pages, paperback, $19.99)

Fine Art Publicity: The Complete Guide for Galleries and Artists, Second Edition
by Susan Abbott (6 × 9, 192 pages, paperback, $19.95)

How to Start and Run a Commercial Art Gallery, Second Edition
by Edward Winkleman (6 × 9, 304 pages, paperback, $24.95)

Selling Contemporary Art: How to Navigate the Evolving Market
by Edward Winkleman (6 × 9, 360 pages, hardcover, $24.99)

The Artist-Gallery Partnership, Revised Edition: A Practical Guide to Consigning Art
by Tad Crawford and Susan Mellon (6 × 9, 224 pages, paperback, $19.95)

The Artist's Complete Health and Safety Guide, Third Edition
by Monona Rossol (6 × 9, 416 pages, paperback, $24.95)

Learning by Heart
by Corita Kent and Jan Steward (6⁷/₈ × 9, 232 pages, paperback, $24.95)

The Quotable Artist
by Peggy Hadden (7½ × 7½, 224 pages, paperback, $16.95)

Guide to Getting Arts Grants
by Ellen Liberatori (6 × 9, 272 pages, paperback, $19.95)

Making It in the Art World: New Approaches to Galleries, Shows, and Raising Money
by Brainard Cary (6 × 9, 256 pages, paperback, $19.95)

The Art World Demystified: How Artists Define and Achieve Their Goals
by Brainard Carey (6 × 9, 256 pages, paperback, $19.99)

Starting Your Career as an Artist, Third Edition
by Stacy Miller and Angie Wojak (6 × 9, 336 pages, paperback, $24.99)

To see our complete catalog or to order online, please visit *www.allworth.com*.